CONTENTS

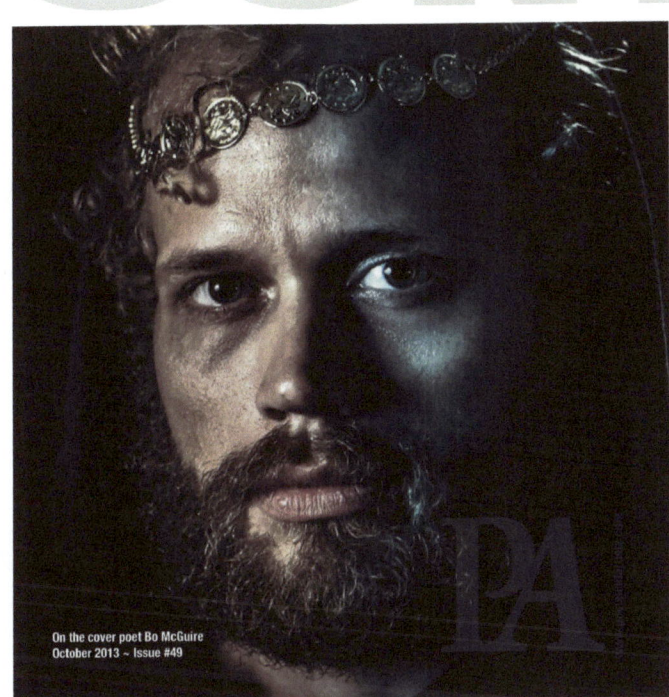

On the cover poet Bo McGuire
October 2013 ~ Issue #49

Photos of Bo McGuire by Joshua James Richards, David Kestin and Sheldon Chau (cover).

Poetry Editors

Helen Vitoria
Michelle McEwen
Timothy Brainard
Cheryl Townsend

Didi Menendez Publishes PA
Bloomington, Illinois
GOSS 183

Short Story
Kirk Curnutt

Poets
Bo McGuire
Anne Champion
P.J. Mills

Artists
Timothy Robert Smith
Alla Bartoshchuk
Jaime Valero
Emily Burns

OCTOBER 2013

www.poetsandartists.com

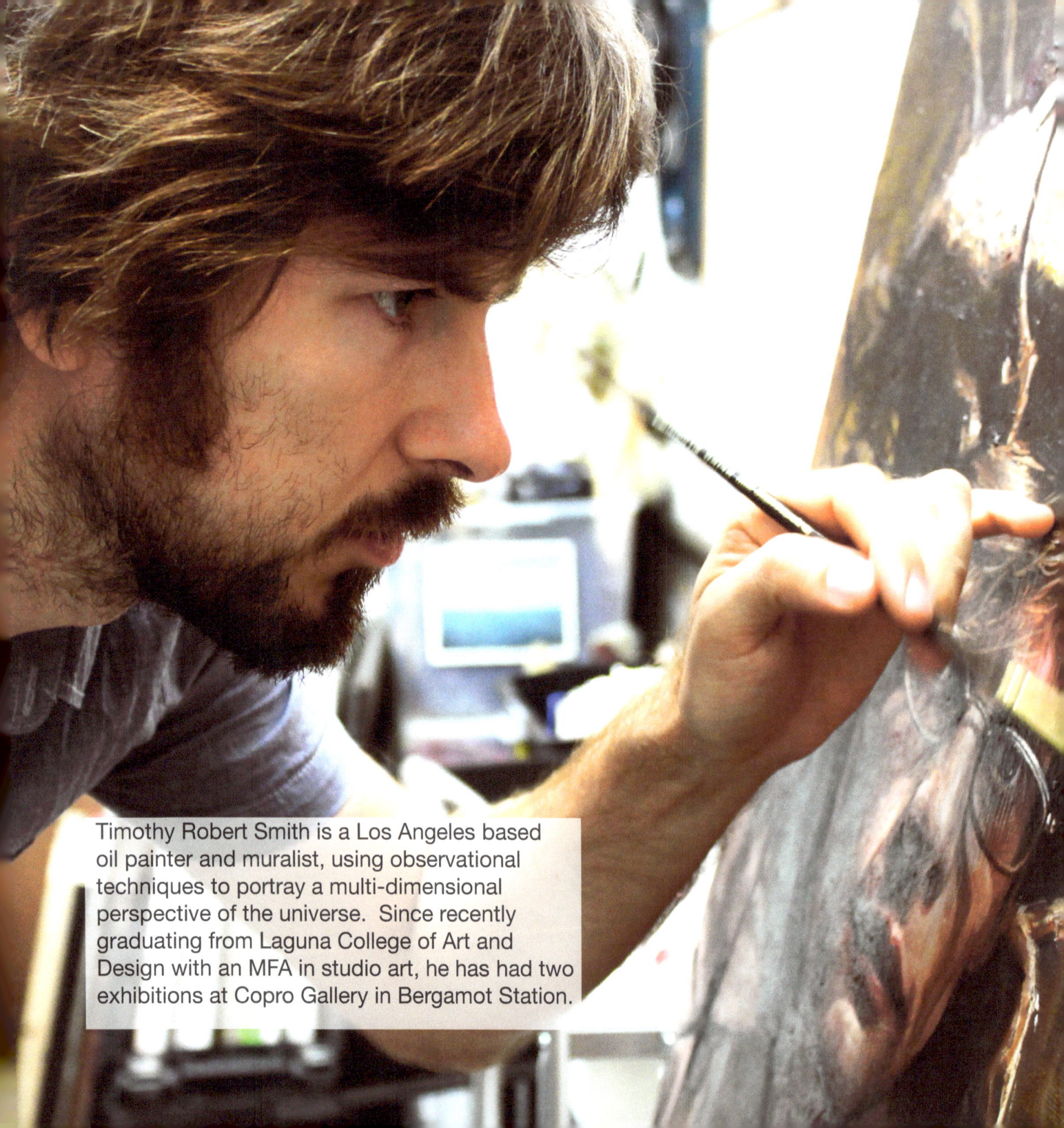

Timothy Robert Smith is a Los Angeles based oil painter and muralist, using observational techniques to portray a multi-dimensional perspective of the universe. Since recently graduating from Laguna College of Art and Design with an MFA in studio art, he has had two exhibitions at Copro Gallery in Bergamot Station.

ARTIST STATEMENT

Kaledoscopic Realism

Timothy Robert Smith

Steven Hawking and Leonard Mlodinow, in The Grand Design, coined the term "model-dependent realism", claiming that everything we know about reality is from observations based on models. They show that different world picture models prove to be equally valid, making the "true" nature of reality is impossible to pinpoint.

My work is a study of the symbiotic connection that exists between reality and mind. Everything we experience is processed through our consciousness, filtered by a learned belief system and the unwritten rules of a rapidly changing culture. I am fascinated with the diversity of human perception; how the world is interpreted differently from our own vantage points, and how these individual views work together to form an agreed-upon picture of the universe.

I've developed my own style of painting, channeling traditional techniques into cinematic scenes with overlapping dimensions. Through a new means of constructing physical space, I entice viewers to experience a painting as if they are actually living inside of it. Objects can be seen from multiple vantage points at the same time; like in cubism, but through a realist's lens. As the viewer's focus shifts around the painting, the edges of objects shift with them. Angles intersect, becoming more disjointed towards the outer regions of the canvas, creating kaleidoscopic landscapes that pull viewers into the vortex.

My subject matter is derived from my experiences traveling and living in metropolitan areas. I see strangers interacting briefly, transitioning through the stages of life in a constant state of motion. The characters in my paintings are everyday people you can find in the city; riding trains, buses, and escalators. They might live nearby, or come from an unknown dimension. Each character has a personal reality, which collectively forms into mass existence. There are many paths to explore, all of which are important pieces of the story.

Several vignettes work together kinetically to create a parable, like a zen koan; containing paradoxical elements that, when meditated upon, inspire viewers to abandon their logical minds. Upon recognizing the absurdity of life's situation, we momentarily take ourselves out of the game. From this comes enlightenment; and empowerment. Artists are modern day shamans; storytellers communicating through an intuitive understanding that lies beyond words. My message, as an artist and as a human being, has always been the same. It is about recognizing infinite possibilities, and finding the inner clarity and strength needed to become the director of your own story. I hope my painted visions can inspire others to do so.

INTERVIEW

Tell us what you do when you are not creating art.

I like to write and record music. I play banjo like a sitar to make a strange mix of psychedelic, bluegrass and punk. It's fun, but it takes me about a year to write a good song. Before that, I fronted in a three piece punk band, but we went our own ways, and now I just do solo recording.

I also like to wander, explore forests, caves, desolate places in the city, meet strangers, study people. I enjoy reading about physics, mythology and consciousness, and the occasional mind-bending novel. Traveling is great; camping, bicycling, cross country motorcycle trips, Death Valley, sleeping under the stars.

How often do you stretch outside of your comfort zone?

Always. I am constantly experimenting, trying new things, taking risks, and making mistakes that end up leading me somewhere unexpected and interesting. As soon as I start to sense that I'm in a "comfort zone", I feel trapped, and react violently. For me, art is about surprise and revelation, which only comes from venturing into the unknown. If I know exactly what is going to happen, I'll just be following a script, and it's a waste of time, for me and for the viewer. I'm always trying to break outside of whatever box I find myself in, which puts me in the box of not-wanting-to-be-in-a-box; but, eventually, I'll break out of that one too.

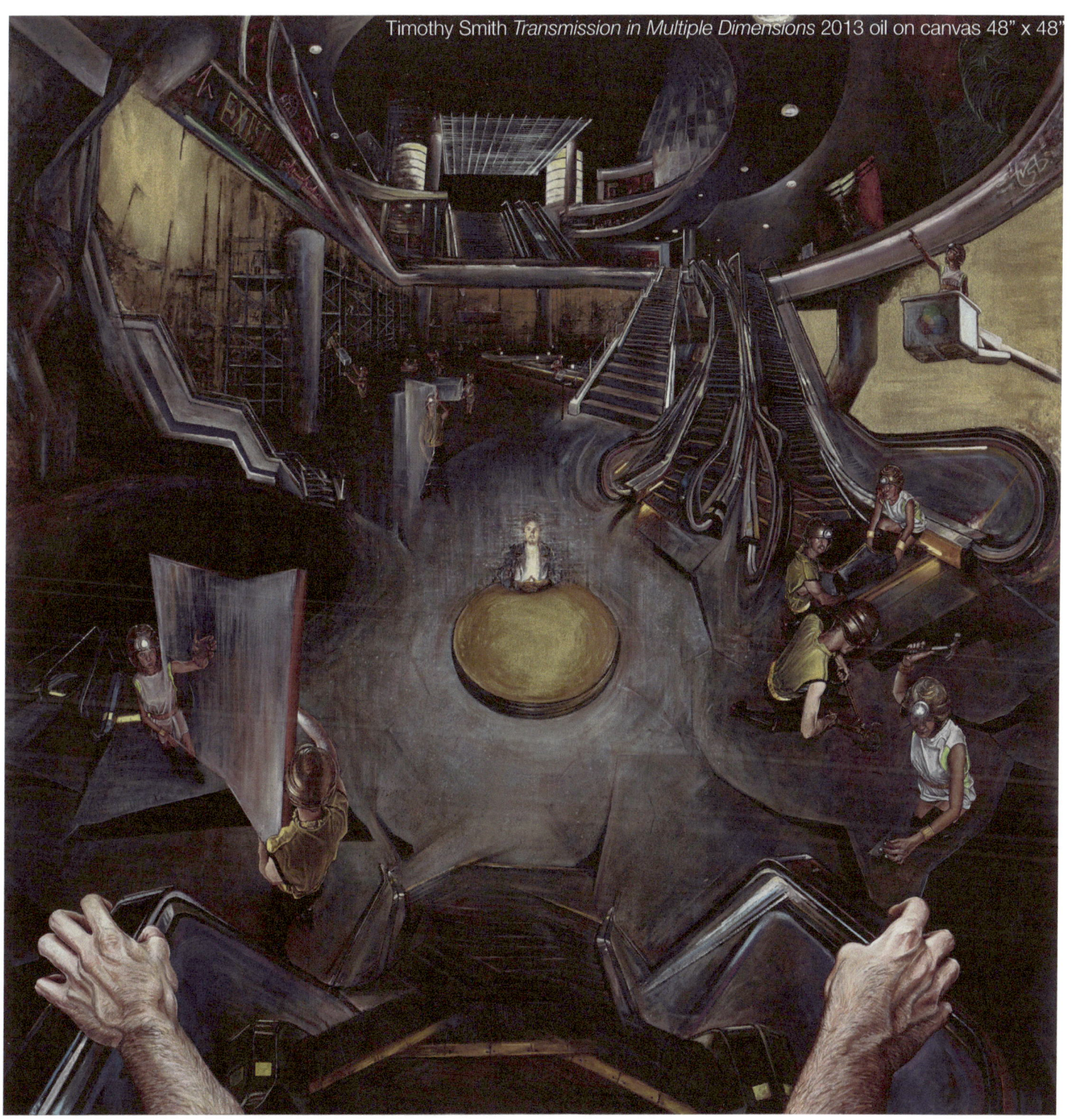

Timothy Smith *Transmission in Multiple Dimensions* 2013 oil on canvas 48" x 48"

Timothy Robert Smith

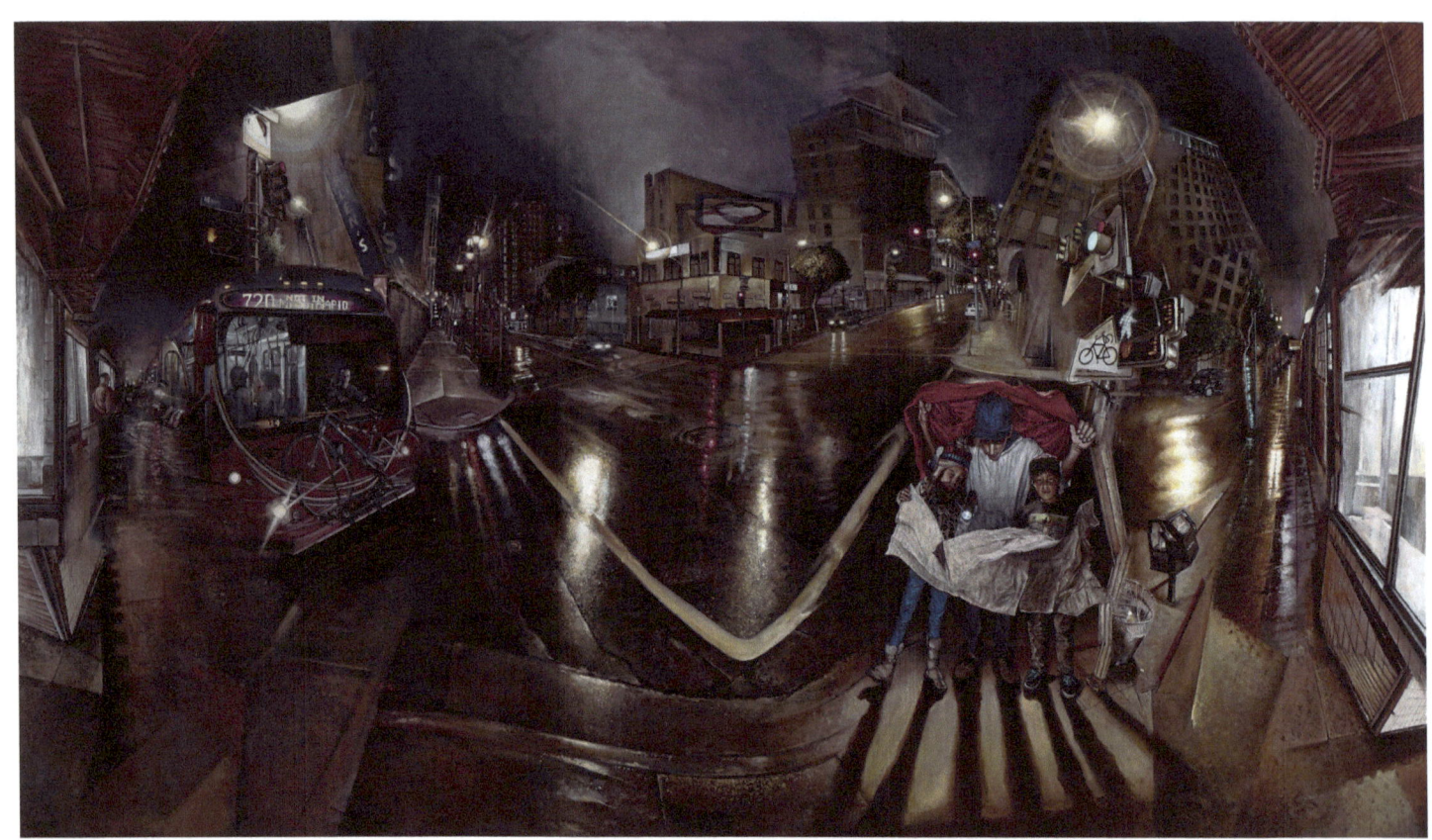

Revised Maps of the Present 2013
oil on canvas
60" x 108"

Timothy Robert Smith

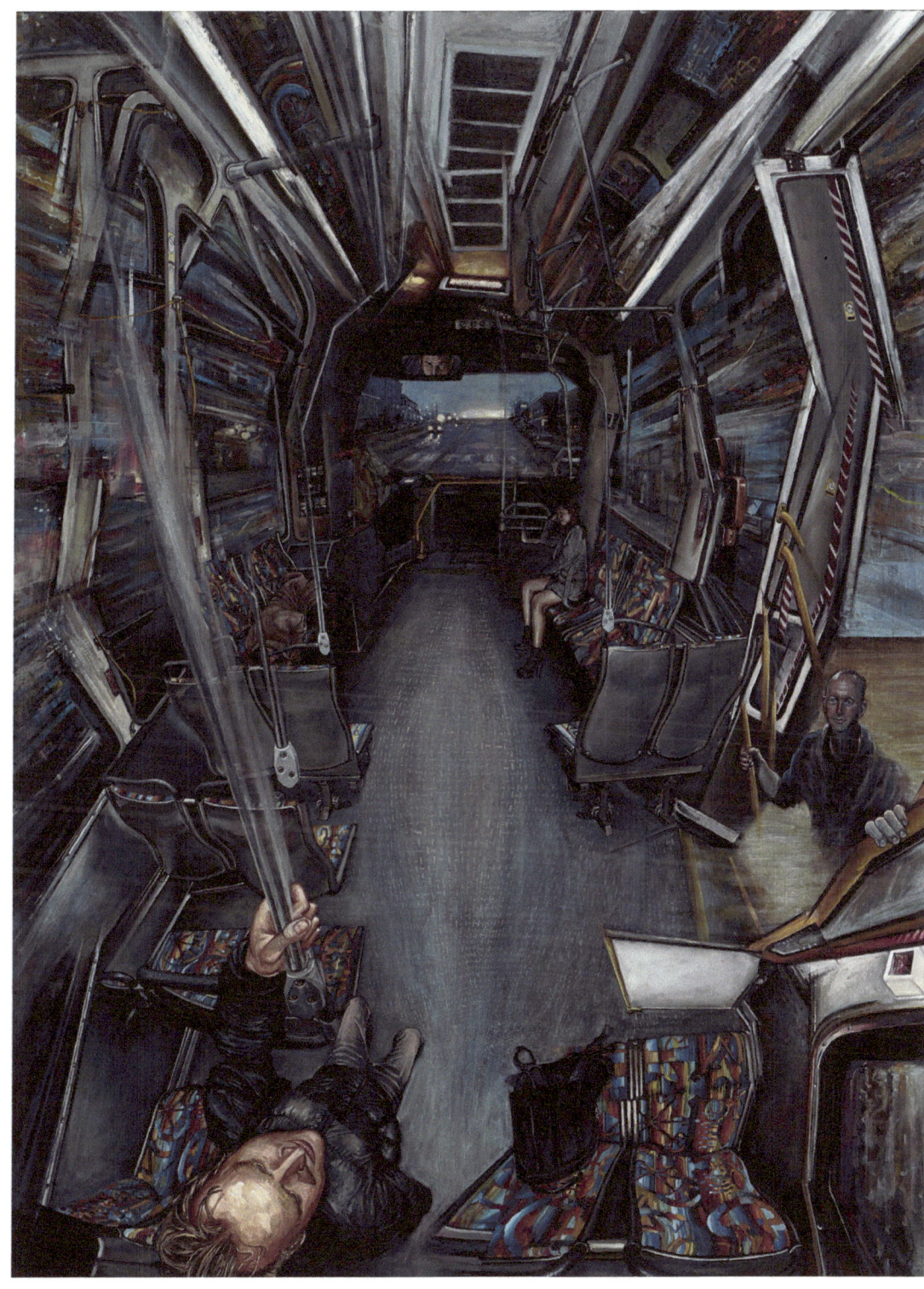

Entranced in Transit 2013 oil on canvas 48" x 48"

P&A October 2013 www.poetsandartists.com

Timothy Robert Smith

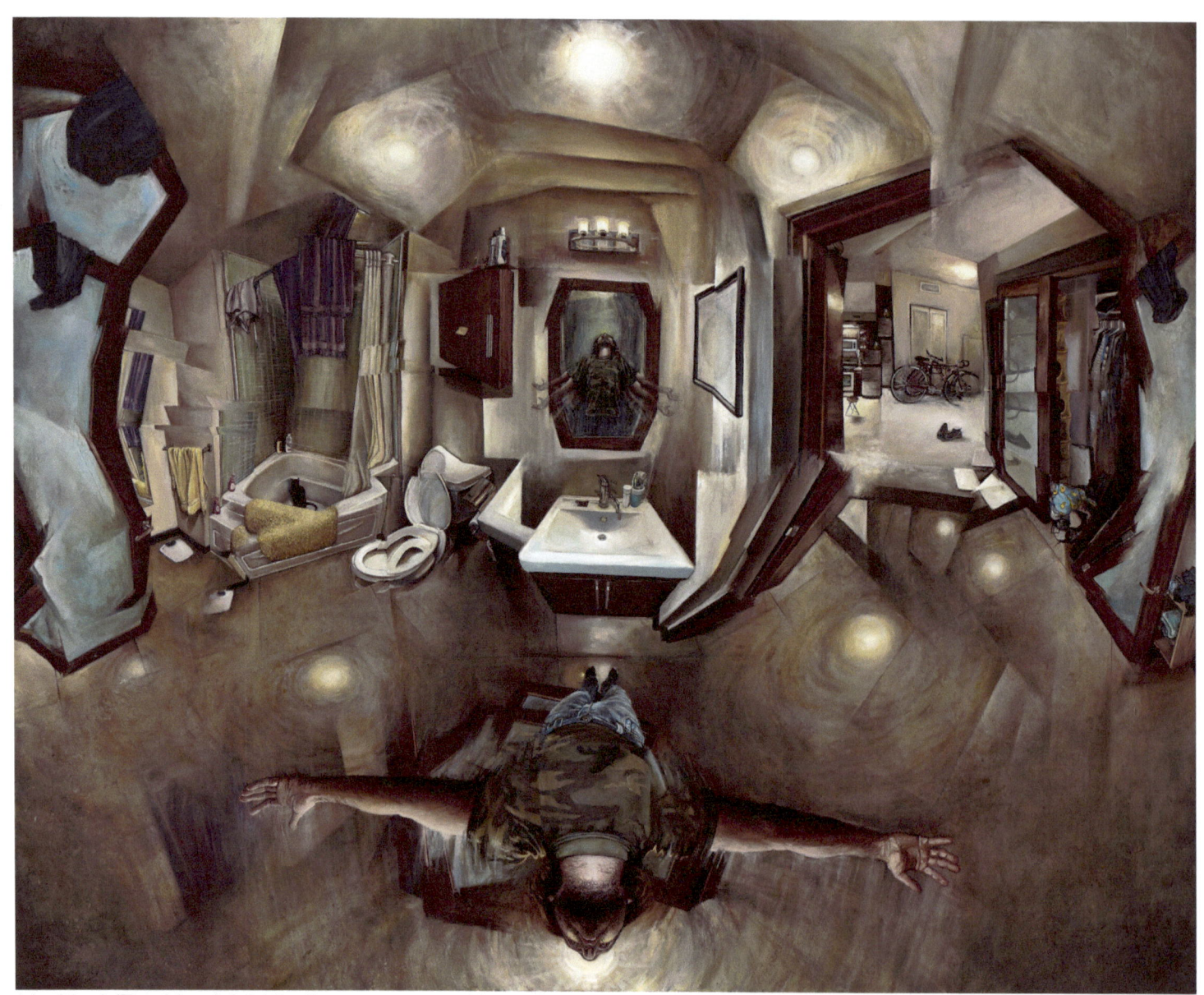

Untitled (For Now) 2013 oil on canvas 48" x 60"

Alla Bartoshchuk

Born in Rivne Ukraine in 1988, Alla Bartoshchuk came to the United States in 2005 to pursue education and career in fine arts. She graduated Magna Cum Laude with Bachelor of Fine Art in painting from Memphis College of Art in 2010. In June 2013 she received her Masters of Fine Art degree in painting from the Laguna College of Art and Design.

Alla is a recipient of Elizabeth Greenshields Foundation Awards (2012 and 2013). Her work is represented by Hall/Spassov Gallery in Bellevue, WA, where she is scheduled to have her second solo show in December, 2013. Currently, Alla resides in San Diego, CA.

Figurative representational paintings.

"Similarly to many fine artists, I find studio practice an important element in contributing to the production and evolution of my work. I think "studio" is a state of mind – a "laboratory" where painting process is defined as investigation. In this respect I identify with Cezanne's process, who wrote: "The landscape reflects on itself, is humanized, thinks itself in me. I objectify it, project it, fix it on my canvas." I too, attempt, to analyze, internalize and filter the observed reality in my work, rather than simply imitating it.

When faced with a blank canvas, I do not always know where the process will take me. Painting is a search. Essentially, embodying the process of individuation, painting allows me to tap into the well of the collective unconscious and discover the unknown. Primarily, it fosters not the rational, but the emotional interpretation of the world, allowing me to understand myself in relationship to the complexity of experiences I encounter."

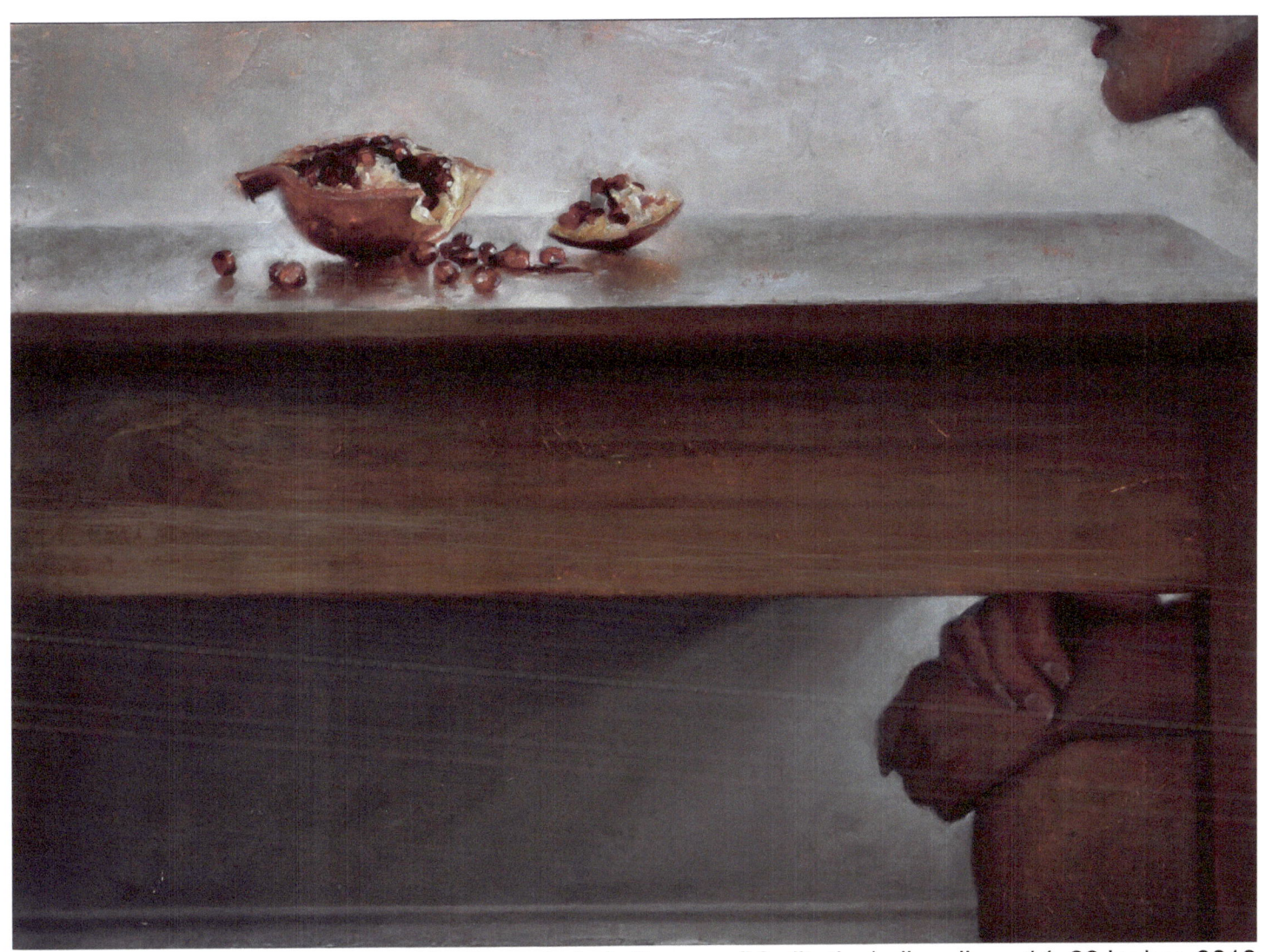

Alla Bartoshchuk *Роздум (Meditation)* oil on linen 14x20 inches 2013

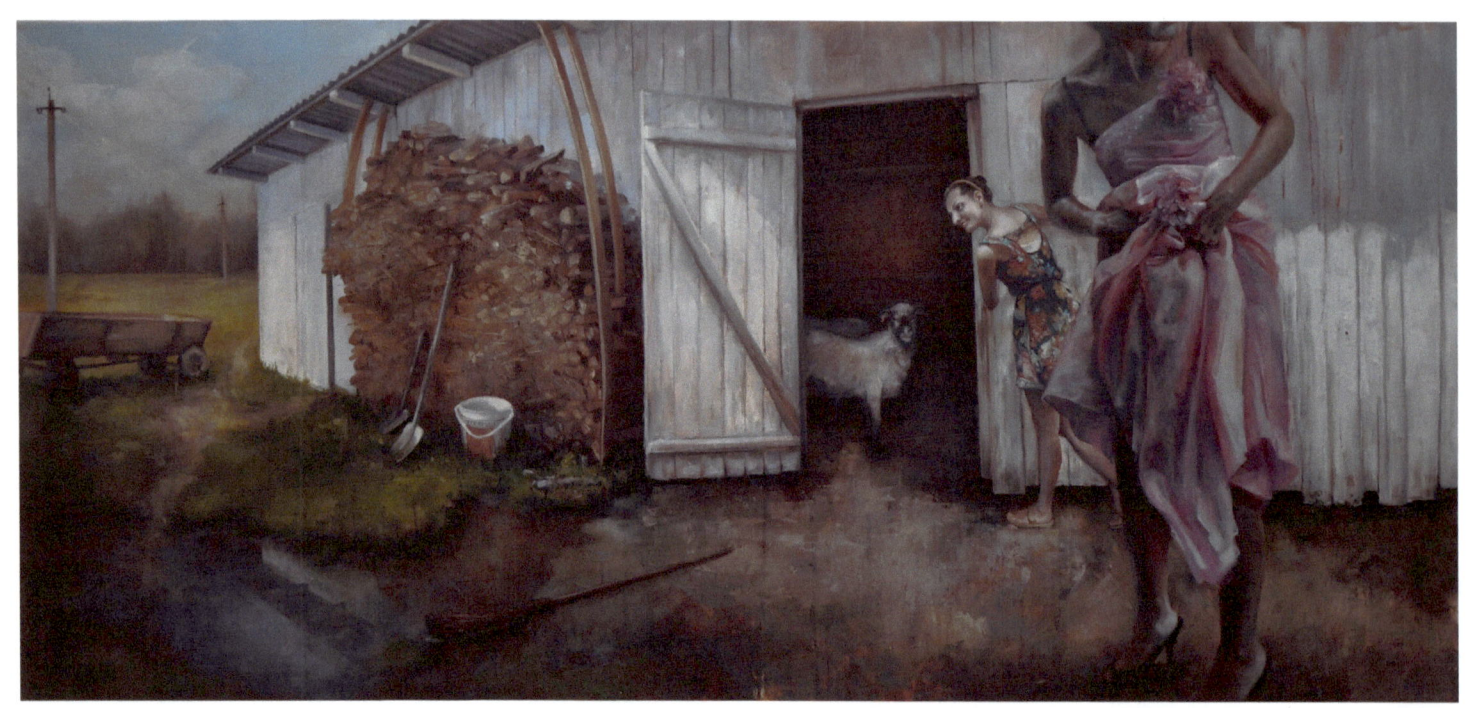

Alla Bartoshchuk *Роздоріжжя (Crossroads)* oil on canvas 28x62 inches 2012

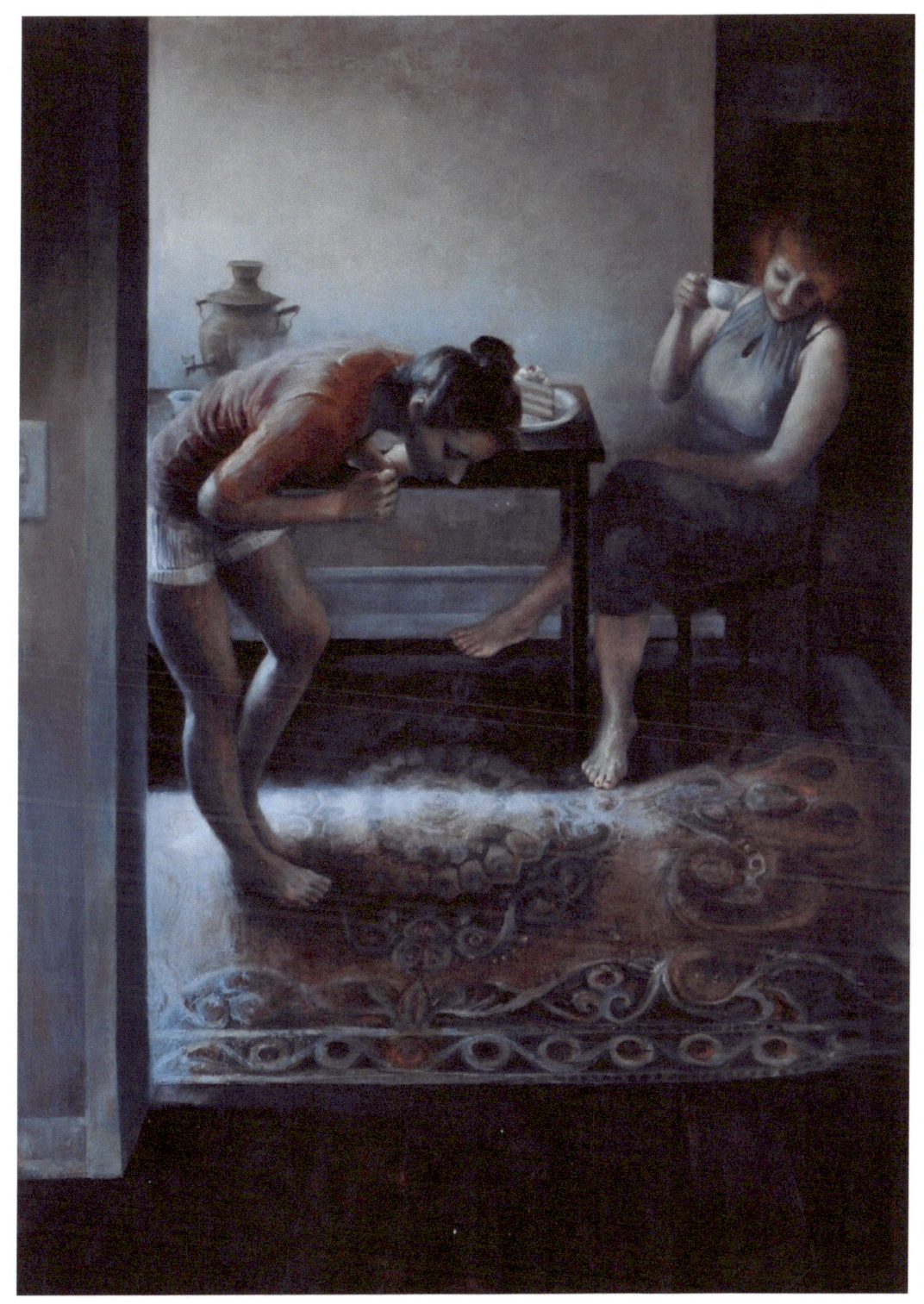

Alla Bartoshchuk *Коло* (Circle), oil on linen 36x54" 2013

Alla Bartoshchuk *Park* oil on canvas 38x48 inches 2013

Buck Prayer

alabama hot sun rusting on a hot hook loose
you are running hot-headed straight into the deep hell of it

with them legs in the middle of a pasture
with them cows you are in the thick of summer
with that thick head climbing kudzu

don't be scared smoking against God's barn doors
don't be scared of a boy with a hot car
don't be scare up against a tire watching
how the cows dream

stretch your neck. unfolding
the day is its own brutal work

the bones in your neck crack
a yellowhammer flies

Bo McGuire

I hail from Hokes Bluff, Alabama—a glorious hamlet nestled in Dolly Parton's cleavage. Daddy was the Waffle House third-shift cook. Mama was his waitress. There is a great family story of how I once pronounced bosom like bozoom. There is also the legend of how Nanny went to get the shot-gun when she got mad. I write poems because they call to me. I love because love comes to me. When love does not come, I go get the shot-gun. I shoot at the love, but I never quite kill it. I believe in Beyonce. I believe in home. I believe in me. I believe in ghosts. I believe in witches. I believe in you. I know what you did. I was there when you did it.

In the Dark Prayer

belonging to no one is like belonging to no one
struggle. what do i know about it?

look to the moon before we remember
we forget the sound of flies—a fancy mistake

You lie

people say the most cinematic trains
i don't believe them. i tell them
to take a dip of pain—pull it
through the edge of their bones

our eye-lines are off—the seams
show the tricky rope of language

hold out your lips. bite at the rash
breaking prayers over a lover's head—a hatchet

everybody breaks in middle of the dark
it's easy to believe it's caused by labor
it has to do with heavy air

running the hares—hunting the hounds
the cows are crying. i don't know how you kill
a cow. i buy it. it goes by so fast
i want to punch myself lipstick red in the face

people will tell you everything will pass
i am telling You

feel this hurt in me that doesn't hurt
feel how too much beauty rattles out your bones

i am being honest
near death and lost in the dark
you can feel everything

tell me what You feel
tell me again

Jaime Valero

Portrait Number 5 2013 oil on board 47x58"

Interview

Jaime you just completed a large scale drawing and sent it a gallery in Mykonos. Do you find it is easier to sell larger or smaller works?

Surprisingly, specially in these crazy years struggling through the crisis, I think larger pieces are selling better than small ones. Some gallerists commented to me that they are suffering the crisis more severily on low or médium prized pieces and selling better those with higher prices, the larger pieces.

How many of your works end up in collections in a year's time-frame?

It really varies a lot depending on the year. Because of the kind of pieces I am working on lately (large scale portraits, my favourite), when I sell them they usually end up in private collections, since they are not a "decorative" subject. Sometimes through galleries, sometimes directly to the client, but the truth is that, if I am not pressed by a deadline, I like to dedicate at least, some months to each piece, so I don't complete many a year, maybe three or four of the bigger sizes.

Where do you find your inspiration from and do you ever find yourself not knowing what to paint next?

I think we feed our souls with our daily life and "everything" around it will be part of our work (books, movies, conversations, experiences,...). So new ideas or projects could show up on the most unexpected situation or moments.

I understand my work as a whole, a big puzzle where every new painting turns into a new piece to finally, maybe, one day, help it all make sense together. Basically, when I "feel" the need of working on a certain body of work, I let my obsessions and my subsconcience take control. I don't want (nor think I could), always explain or rationalize what I do and why I do it. I think part of the magic around art lays in the inexplainable, either to enjoy a piece of art or to create it.

I have never found myself not knowing what to do, but mostly on the opposite situation. Because of this way to understand my work, I am constantly starting new

projects and openning new ways and lines of work and because of it, many times, I find myself developing several works at a time, which is greatly enriching to me but very chaotic for my organization.

For instance, right now, I have four or five different pieces or projects on the way: working on two collaborations with Poetsandartists, working on new pieces for Rarity Gallery (four new pieces for next March), finishing my first Artist Book, a private portrait comisión (40x150 inches) and a long distance/run Project based on the limits between photography and painting and its possibilities, which includes writings, sketches, photographies, oils and different mixed media pieces.

Are you ever strayed by your artwork and take a different path to what you originally were thinking or is all your work calculated?

This is a very interesting question. The way I understand art, most of what makes or defines our work happens "before" we start painting, before we even get the eassel ready. Is that part of the work where we try, sketch, draw, take pictures, write, think… in one word, define what we are going to work on. In that part of the Project I try "everything" and am open to any kind of change or new posible way.

Once I start working on the piece, it all depends on what kind of piece I am working on, what media, what destiny, what purpose… A private portrait commision will allow a mínimum variation once I have decided the image to work from. On the other hand, my Artist Book or the painting/photography project will allow me to switch and change as much as I want and the more I do it the richer the outcome and the projects themself will get.

When working, for instance, on a large scale portrait, I know where I want to get, but what parts will be more or less defined or detailed or the shades and hues in color and texture will be always open to changes as I go. The process I have developed is based on deciding every new sesión, depending on what you find on the board, what is next, what is done or what can be changed.

Do you use any external objects such as projectors to prepare your work on the canvas?

I still use the traditional way, a couple of axises to place 15 or 20 main points to build the whole structure of the drawing. I like this way cause it allows me to make a personal drawing. I mean, after so many years, I know exactly how I want the drawing, what parts need more details, what details would be useless, etc. So what I finally have when I am about to start with the color is a "map" full of the exact information I need for the first coat of color.

Of course, all this applies when the drawing is going to be covered by color. If I work for a drawing, the process would be completely different since everything is going to be there for good and need to work as a whole, aiming to the final stage.

But in any case I don´t use any external support. I don´t mean I reject its use, it is only that I don´t feel confortable with them.

What are you working on next?

As I said, I am currently working on five or six different things but, talking about specific pieces and destinations, I just finished a large scale portrait for the Foundation of the Arts and Artists Painting Award (it has been given a Honored Mention and will be showed at the MEAM, European Museum of Modern Art, next October). Another four pieces starting a new series of "Sea Portraits" (large scale portraits of faces in the ocean), for Rarity Gallery, a smaller drawing soon heading to London and a private portrait commision of another large scale portrait with four faces (40x150 inches).

Jaime Valero is born in Madrid, Spain, on January 16th, 1967. He will soon show his skills and interest for drawing and painting and will guide his studies to Fine Art School at Complutense University in Madrid in 1985. After getting his Bachelor´s Degree, he will teach art and drawing for six years and then will start his professional career as an artist (1996). For the last seventeen years he has been building his own style and imagery, primary focused on portraiture and figure, though trying every other possible field.

For two years (2001-2003), he lived in US, and there he started investigating the possibilities of large-scale portraits and nudes in water and, ever since, he has dedicated most of his works to open new doors and ways related to this universe in what is his most personal and particular obsession.

Over a year ago he started a new project through the internet to share, freely and non profit, processes and procedures with any other artist interested all over the world. Up to date, he has created five different videos, in English and Spanish, to open his studio and its secrets to everybody out there who could be interested. ("Come In and Help Yourself Project"). In the last year he has started a new and, so far, very successful relation with Rarity Gallery in Mykonos where he will be showing new work next April.

Jaime Valero *Portrait Number 6* 2013 Graphite on Paper Glued to Board 72x48"

Kirk Curnutt

Moves Like Updike

My best friend's son just dropped a bombshell: he's not even ten yet, and he's already scored his first kiss.

Why Lleyton decides to share this milestone is a knotty matter. I can't tell if the kid's confiding in me or rubbing my nose in the revelation. On the one hand, I am the closest thing to a stable male role model he has, having served as his mother's drinking buddy/handyman/tax preparer since she bought the house next to mine after divorcing her Petri dish of a husband almost a decade ago. The idea of me as anybody's guiding light on masculinity is dubious enough, but my relationship with Lleyton is complicated by the nature of my friendship with his mom. Campbell self-identifies as gay, yet from time to time she's been known to fall off the wagon and onto me. It doesn't happen often—maybe once or twice a year if we aren't otherwise committed. Out of respect for the kid we go to great lengths to keep our dabbling hush-hush: no sleepovers, no public displays of affection. I suspect Lleyton senses when I tiptoe past his bedroom door at two a.m., though. For days afterward he's mouthy and competitive. Bragging about this liplock is his latest way of letting me know he's the alpha on the block. Especially when he tells me who he's kissed:

My daughter, Chloe.

"Correct me if I'm wrong," I say when he breaks the news, "but there's a bit of an age difference to overcome, isn't there? Last time I checked, you're nine, and Chloe's sixteen. How exactly did this kiss

happen?"

"Did she tell you about it?"

"Clearly not if I'm asking you."

"She could've told you and you could just be checking to see if I'm lying."

I have to hand it to the kid. Lleyton's crafty. He knows Chloe hasn't told me anything of this incident because Chloe hasn't told me anything lately. She's not living with me right now. A week ago she dumped clothes in a laundry basket and announced she's staying with Campbell until I come to my senses. By senses she means the insanely restrictive rules I decreed to thwart the hots of her boyfriend, who roves our house with all the subtlety of a schnauzer humping the furniture. I'm living testimony to the need for leash laws for boys. I got Chloe's mom pregnant the summer we graduated high school. While I don't regret growing up fast, it messed up the poor woman to the point I've been the custodial parent for most of my daughter's life. I tell Chloe I'm only doing what a good parent does, protecting her and all, but she takes it personally, insisting I don't trust her. What sent her packing was a single word: libido. Specifically, "Just because I trust you doesn't mean I have to trust the teenage libido." Her last words out the door were, "It's always about sex with you." Now I regret letting her run to Campbell's. It's always about sex with the world, and I've pushed my daughter into the arms of a prepubescent kissing bandit.

"We were watching TV," Lleyton explains, "and she had her earphones on, listening to music, and I was running around the room, I don't know why. She told me to calm down. I was behind the La-Z-Boy when she said it, and I just threw myself over the top and my face hung upside down in front of hers, and I just did it. I kissed her."

"What did Chloe do?"

The kid takes a wide bite of the pizza we've had delivered so I won't have to cook for him. The sauce

rings his mouth like blood around vampire lips. "She pulled me all the way over by my collar and flipped me onto the floor."

"That's my girl. I hope you're not the only boy she's used that maneuver on."

"That's not all she did. She hit me. Right here—" He taps his breastplate. "Chloe said, 'You're buzzing around me like a mosquito. That must mean you want me to do to you what I do to mosquitos. I swat them.'"

"That's what happens if you're greedy around a girl. They can tell when you are, and they'll smack you. Deservedly so."

"The thing is ... I don't think Chloe wants to babysit me anymore because of it. She won't even talk to me. My mom asked if she'd watch me today and she said, 'I'd rather you ask my dad.' That's why I'm here right now instead of at home. I think I messed up."

"Girls get tired of constantly getting hit on. A lot of times the best thing we Y chromosomes can do is be their friend. Less leering, less lunging, more listening. That's a motto for a man to live by. Even when you know she's interested in you."

"That's not what my dad told me."

For a second I'm unsettled by the possibility that I've been set up, that this whole conversation is a ruse designed to let me know my advice doesn't rise to the dude standard. Then a different thought disturbs me even more: *This kid is talking to other men about my daughter. To <u>grown</u> men.* Part of me wants to ask if Lleyton's father mentioned the $7,000 in child support he owes his mother, but somehow that feels desperate.

"What did your dad say?" I ask instead.

Lleyton grins. "He said I need better moves."

* * *

I hate that word almost as much as Chloe hates *libido.* Maybe because few things in life have eluded me more than moves. After Lleyton devours his pizza I turn him loose on my Playstation and sit on the porch watching Campbell's house for signs of my daughter. I can't stop picturing her irritation when the kid crashed onto her without warning. The image doesn't anger as much as embarrass me—both for Lleyton and for Chloe. Because with that pop to the breastplate Lleyton received his initiation into that aspect of desire that if you're at all self-aware as a man you end up sweating over: the aspect that says by virtue of the chromosomal quirk of being male you've inherited the privilege (or is it the obligation?) to be the taker, the one who gets, and that with that privilege or obligation or whatever it is, you risk rejection, which is about the only thing short of death and intimacy a man really fears. As for Chloe, I'm guessing the incident was less scary that dreary, a mere confirmation of what three months of dating The Humping Schnauzer has probably taught her—namely, that when it comes to moves most men have all the grace of an ostrich in a mating dance.

I know this because I, too, once had a babysitter.

Julie Jackoboice was her name. She was fifteen the summer my parents hired her to watch over me. It was a job she seemed to think she was best able to perform by lying on a chaise longue by our pool, reading paperbacks and cranking Terence Trent D'Arby on a boombox. Why I needed to be babysat was a painful subject. I'd been a latchkey kid since starting kindergarten, so to be saddled with supervision at the wise old age of ten was an insult. My parents had a reason for not leaving me alone anymore, but we didn't talk about it, so I rebelled by holing up in my room and ignoring the new warden as much as possible—which suited Julie just fine. For the first few weeks she only acknowledged my existence when she called for the peanut butter sandwiches and Pringles she noshed on from 9 to 5. Then one day when boredom had set in she appeared at my door in a lime green romper, a book of my mother's in one hand and a beer of my

father's in the other.

"I need to see some ID," I said, nodding at the latter. "I don't think you're eighteen."

"It's twenty-one, dummy. The law just changed. This is your mom's, I take it?"

She held the cover out toward me. I'd seen it around the house: *Couples* by John Updike. My mother owned a shelf of Updike first editions, every novel and story collection he'd published to that point. Her devotion amused smug little Julie Jackoboice. She asked if Mom would get pissed knowing her babysitter thumbed through her books.

"If you get in the inner tube with it in and the pages get wet, probably. But if you stay in the house to look at it, I guess that's okay."

"I'm not talking about taking them to the pool, dummy. I'm asking if she'd get mad because of what's in these books. Don't you know? These are dirty reads."

I had a vague intuition what she meant. My father was the Carpet King of Dalton, Georgia, and when dragged along on installation jobs I'd heard men who worked for him reel off obscenities that left the air reeking of tar, whiskey, and mayonnaise. Once, a crewmember running me home in his AMC Javelin showed me a nudie biker mag. Every single woman in it looked exactly like the lead guitarist for Mötley Crüe, only with breasts. That was my image of dirty. I knew an abstraction called sex existed in this world but experience had led me to believe it was the province of sinister, haggard men who carried x-acto knives and hammer tackers and browbeat my old man for cash advances. Not until Julie Jackoboice did I ever imagine dirty could be so pretty.

> **These came not just from Couples either, but from Rabbit, Run, Marry Me, The Witches of Eastwick, and S. Julie burned through a book a day.**

She took *Couples* to the patio and lowered herself vertically into the inner tube, floating with her legs kicking under her and the novel's spine hovering perilously close to the wet lapping. That night after Julie left and my parents had collapsed into sleep I snuck to my mother's shelf and pored over the pages. They smelled like chlorine and dotting several were fingerprints formed from a combination of perspiration, water, and potato-chip grease. My eyes locked on a sentence: *Mouths ... are noble. We send our genitals mating down below like peasants, but when the mouth condescends, mind and body marry. To eat another is sacred.* I followed the trail of prints for a half-hour until I grew afraid I might drift off face down on the book's deckled edges. Before I returned the hardback to its place I unfolded the dog-ear Julie made on page 529, where the passage about mating genitals appeared. I had no clue what the words said, but I wanted Julie to know I'd been there.

Only she didn't notice. For several nights in a row I retraced her reading, smoothing out her frequent tabbing. I suspected Julie Jackoboice crinkled page tips by the tens to test my mother, seeing if Mom actually cracked her books open or if they were displayed for show. Meanwhile, my head flooded with mysterious phrases. There was "mixed fur," "mixed liquids," and "rubescent pudendum." These came not just from *Couples* either, but from *Rabbit, Run, Marry Me, The Witches of Eastwick*, and S. Julie burned through a book a day. Either she was a speed reader or she skimmed for the saucy bits.

Somewhere in the middle of *A Month of Sundays* I broke down and decided I couldn't take her being oblivious to me. In a chapter with so many big words I thought I would swallow my tongue trying to pronounce them I left blatant evidence that I'd shadowed her sailings through this Updikean ocean. Sure enough, the next day she was at my bedroom door, dripping wet in a plaid bikini, holding the novel open at me.

"Did you do this?" She tapped at something foreign to the page.

I played dumbed: "What is it?"

"It's an underline, dummy. Somebody underlined a sentence. I'm pretty sure it wasn't your mom. I'm pretty sure it was you."

"How's come you think it was me?"

"The underline is in colored pencil." She nodded at my desk, where a set of Dixon Thinex thin leads lay next to an unfinished comic book. The pencils had been my mother's as a child. Julie studied the passage, silently. "You like this, huh? What a freak. You want me to read this to you? Is that what the underlining's all about?"

It was indeed. I did want her to read it to me. I wanted that more than I wanted oxygen, but I couldn't tell Julie Jackoboice that. Apparently my face was far from a blank slate.

"All right." She clapped *Sundays* shut. "Tonight. I'm pulling a double shift so your folks can go to dinner. I'll read it to you, hornball, but you're doing me a favor, hear me?"

I'd have assassinated a president for her. I asked what.

"My boyfriend is coming over tonight. To hang out, maybe watch a movie, maybe swim. You're going to stay in your dungeon while he's here, and you're not going to breathe a word about him, not to Mom, not to Pop."

My parents took longer to get out of the house that night than it would've taken me to plow through *Rabbit Run*, *Rabbit Redux,* and *Rabbit is Rich*. Probably *Rabbit at Rest*, too, if that doorstop had been around then. Exasperated with their endless bath running and clothes ironing and shoe polishing, I marched up and down their hall, practically picketing their

> **Dad grabbed a fistful of Mom's hair, pulled back her head, and sank his ruby mouth around her pale neck. Then he did something stranger still.**

bedroom, hoping that by being a pest I would hurry them on. Their door usually stayed shut, but on one pass I noticed it'd come ajar. Through the crack I caught my father waddling out of the shower, naked except for a towel. Pink from steam and a hot-water scalding, he snuck up on Mom at her makeup table. She was also as close to naked as a child cares to see the woman who birthed him, wearing nothing but a slip. As Dad pulled her into an impromptu embrace the sight of their bare stomachs rubbing so froze me in horror that I couldn't think to dive out of sight or even look away. With a suave grip no doubt perfected through years of laying shag, Dad grabbed a fistful of Mom's hair, pulled back her head, and sank his ruby mouth around her pale neck. Then he did something stranger still. He stretched his palm across her left breast and squeezed.

There was just one problem with doing that. Mom had no breasts anymore. She'd had a double mastectomy. Before she could undergo reconstructive surgery the radiation had to kill the cancer in the adjoining tissue, which is why I saw two incisions zippering her chest. Only radiation wasn't working. My mother's cancer had metastasized, and the last-ditch scramble to save her was why Julie Jackoboice had been hired to babysit in the first place. My dad's dunderheaded attempt at passion reminded me of something I'd denied all summer. My mother was dying.

To rid myself of that reality I carried an armful of Updike to my room and gorged on every enticing passage I could retrace through Julie's fingerprints and dog-ears. By the time she showed up a-swirl in an aphrodisiacal mixture of Bubble Yum and Sunbonnet Sue Avon perfume I was so itchy I felt as if fire ants had chewed through to my insides. After phoning her boyfriend with directions to our address she slumped onto the couch with a cushion of safety between us. She made no effort to mask how dreary a task this would be for her. It didn't matter. Julie cracked open *A Month of Sundays* and began reciting. Updike's bawdy wordplay sparked into an obscene accelerant. All I heard were sounds, polysyllables as

tangled as bodies, full of hissing fricatives and heaving plosives. By the time she hit the unfathomable image I'd underlined my hormones were so heated I was afraid to reach for a dictionary for fear of combusting: *We bent a world of curves above the soaked knot where our roots merged....*—what did that mean? I didn't know; the very possibility of knowing terrified me, and yet that terror was as exciting as the frisk of crushed velvet on my bare soles.

The passage returned me to the sight of Dad pulling Mom's head back to kiss her neck, that smooth move foiled only by clutching at an amputated breast. There was no conversation there, no negotiation, no resistance. Despite his blunder, Dad seemed to have Mom so totally in his power that all she could do was moan two words that to this day I can't believe anybody outside of a movie made in 1945 would ever say: "Take me."

Where was he supposed to take her? I'd wondered spying through their open door. *Out to the ballpark,* maybe? ...*to her leader?... home, country roads, to the place she belonged?... Take me away, Calgon?* More importantly, if he was taking her somewhere, why wasn't I invited?

Unable to control myself, I reached across the cushion and sank pincers into one of the dunes of the flesh bulging Julie Jackoboice's T-shirt. I barely had time to consider that the lumpy stitching tickling my palm probably wasn't a nipple before the spine of *A Month of Sundays* cracked me across the nose. As I crashed to the floor both the pain in my face and the sensation of falling made me realize why my mom had rewarded my dad's move with that hokey Hollywood line. She wanted Dad to take her so they could both believe, if only for a second, that the cancer wouldn't.

I cried in front of Julie Jackoboice more than I've ever let myself in front of any other woman. When her boyfriend arrived he came up with a lie to explain my broken nose: I'd taken a header into Mom's bookcase horsing around the living room. I was such an uncoordinated kid that my parents never doubted the story.

* * *

A burst of light tugs me from the past. A Toyota Tacoma passes my porch and pulls along Campbell's curb. The Humping Schnauzer's truck. As two figures spill from the cab, I'm aware of several things simultaneously.

Lleyton is still going full throttle on my Playstation.

His mother isn't in the house where my daughter thinks she's taking her boyfriend.

I am two years older than my own mom ever was.

A few more and I'll have outlived the late, great Julie Jackoboice, too. Earlier this spring my dad—still the Carpet King of Dalton, Georgia at eighty—reported she lost control of her Kia in a rainstorm. Sideswiping a tree, she went through her windshield into a cornfield.

The Tacoma's passengers stop in the middle of Campbell's lawn. Through the mist of streetlights I watch the Schnauzer take my daughter's cheeks between his palms and kiss her, deeply. As far as moves go it's a pretty good one. I give the kid a B+, better than I'd give my old man. I start counting backwards from ten. When time's up I'll slam my front door and cough loudly into the night, breaking up the lovers. Chloe will have new reason to complain about what an oppressive father I am. *Don't hate me*, I should yell out to her. *Death is who you ought to resent.* But instead I'll go inside and look for remnants of fingerprints and dog-eared page tips in the first-edition Updikes I keep under lock and key—all I have left of my mother.

The thing is, I hit ten, but I don't put a halt to the make-out session. I don't do much of anything except watch, transfixed, excusing the weirdness of my voyeurism by pretending I'm granting my daughter and her schnauzer another countdown, and then another.

It's only a kiss, after all, and in the scheme of life it doesn't mean a thing.

It's only a kiss, after all, and in the scheme of life it could mean everything.

Visiting With Jeanne

The hot wind blew some straw into her eye.
With her little finger she pulled it
and a strand of hair from her mouth.
One last deep drag of a smoke
and with a thump it was gone.

We tried to invent memories of sweetness but
nothing remained of better days.
There just weren't any.
There was no sign of a future either.
Our sunset was just
a wallpapered mural in a dinner.

The hot wind drove us back into
the hotel where we waited.
Getting into prisons is not easy.
Waiting is like a dripping faucet.

Movies hardly describe the humiliation
that tears at your fiber.
The guards hate us as much as the prisoners.
The stench of changing diapers, constant chatter in Spanish
and the tapping, tapping, packing of fresh cigarettes.

This visit gently rubs our noses in filth.
We didn't do anything but we were there
and now we are here waiting.
Sitting in our misery with fake smiles.

We'll take forced photographs
in front of another wallpapered mural.
Another sunset that doesn't exists
to keep a memory of someone
in a place we'd like to forget.

PJ Mills

I grew up in a violent household. Everything was really out of whack, some didn't make out alive. Fortunately, I got out and somehow I got to study painting. I took some poetry classes with poet Jon Stallworthy and got to meet Seamus Heaney. Poetry became a sort of short hand that could bring me back to a particular moment where I could remember stuff for painting.

I learned about the "imago ignota" and read that the late Irish Poet Seamus Heaney once described as, "it is the combination of words/images, which elevate them beyond the language of the obvious".

Poetry and painting has kept me alive, out of prison, and married to someone I truly love.

more information: www.pjmills.info

Affair

Here is how it all began: we touched
 each other on rooftops, in subway cars,

 beneath bar stools. Nights, you snuck

into my bedroom, so still that only
 your shadow made noise in music that bloomed

 large across my wall as you entered. Candle flames

licked their hungry tongues towards
 my window. You entered me without

 speaking. Other nights, we met in the woods,

unzipping and zipping again as a park cruiser
 drove by. How could I stay away from you?

 How could I not allow your hands to study

the topography of my body? I wanted
 nothing from you, only to consume and be

 consumed, to stick to you the way sap clung

to the bark you pressed my back against,
 its potent scent permeating everything. I ached

 for nature, reckless as torrents of rainfall. On our walk back,

you held the umbrella over my head,

Anne Champion

and my path was lit only by your breathing.

All there was left to do was wait for my tiny eggs to churn

in their assembly line, one unfurling
 into limbs, swimming upstream in its stagnant

 muck. We didn't plan that part. I only intended to soothe

you like a snake charmer's flute. Afterwards,
 I wanted to punish you, rouse your scales with a stick,

 your body lurching to attack, ruining me again and again.

Anne Champion currently teaches writing and literature in Boston, MA. When not grading, lesson planning, or writing, she's sneaking away to read or to watch whatever TV series is her current obsession. (Right now: Homeland and Breaking Bad). She loves vampires, coffee, and cats, and she has two amazing kittens. Find her at anne-champion.com.

Emily Burns

Born in 1986 in Warrenton, Va. and raised in Manassas, Va. and later the small town of Greencastle, Pa., Burns lived on a farm for most of her life, an experience that still influences much of her work. She studied painting at Pennsylvania State University and graduated with a BFA in 2008, the same year her first solo show was held in 2008 at University Park, Pa. In 2010 Burns moved to New York City to work for renowned artist Jeff Koons. In 2012 Burns returned to central Pennsylvania to open her studio and gallery in State College. Her work has been shown both nationally and internationally, and was recently included in a solo exhibition at Adventureland Gallery in Chicago, and group exhibitions at 111 Minna Gallery in San Francisco and Above Second Gallery in Hong Kong. She currently divides her time between Lemont, Pa. and New York City. Her work investigates human nature, gender and social roles through the figure as well as abstraction. References from the past and present create her visual language by merging the modern image making techniques of digital photography, advertising, and photoshop with the techniques of traditional oil painting.

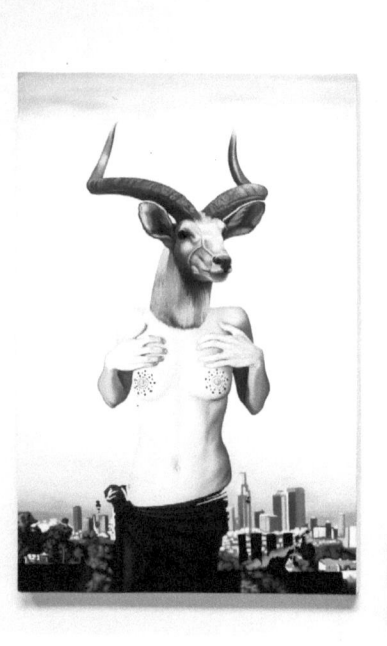

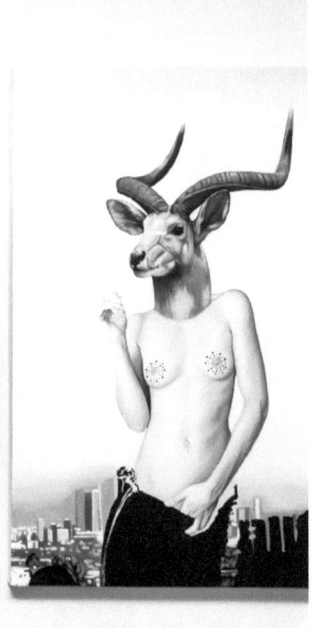

STATEMENT

My recent work seeks to create a dialogue about the history of imagery, primarily as it pertains to the use of the modern American female. I am interested in the evolution of these images from classical painting, photography, advertising, television, and internet and the the subliminal messages and psychological effects they proliferate. My compositions are created by collaging, breaking apart, and rebuilding the parallel environments of human and animals worlds, while rendering the subjects anonymous within them. I am interested in the viewer's engagement with the characters, the distinct fallacies they represent, and their connection with kitsch, and their relationship to society's ideals.

Emily Burns

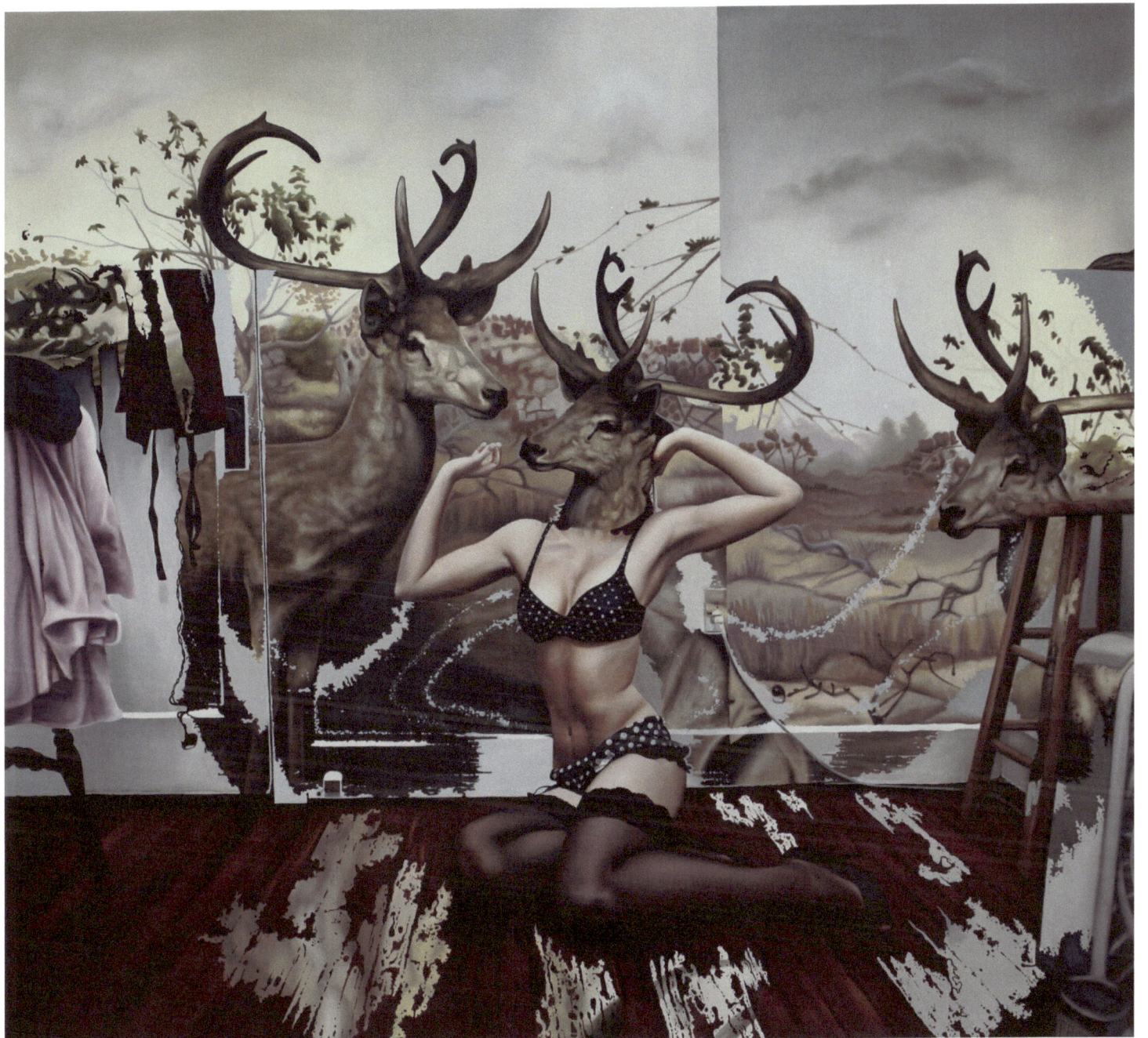

The Three Daughters of Mara 2012 oil on canvas 52 x 48"

Emily Burns *Like an American* 2013, oil on canvas 22 x 32"

P&A October 2013 www.poetsandartists.com

Emily Burns

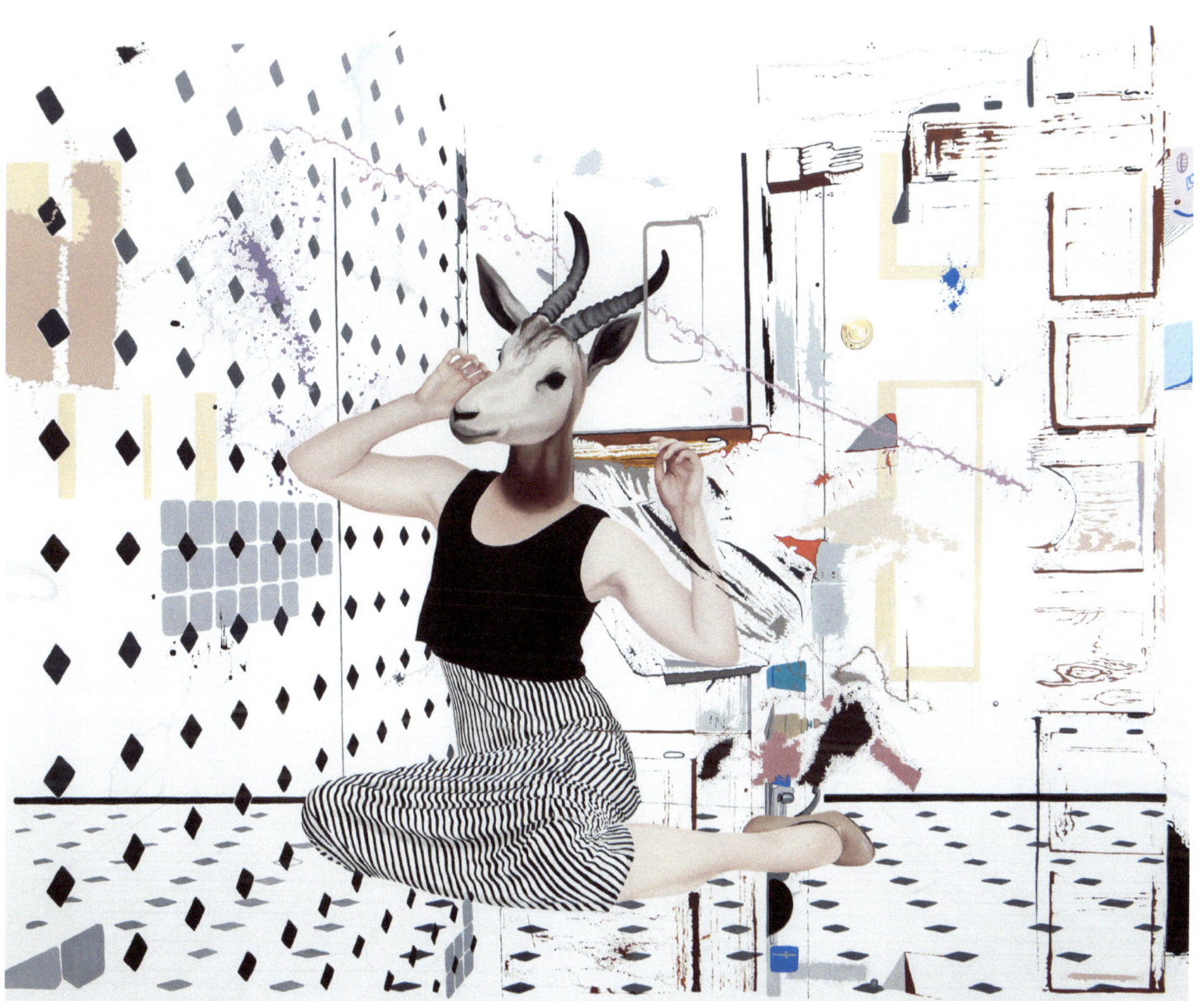

Tactile Response to Mechanism 2013 ink, acrylic and oil on illustration board 30 x 36"

Emily Burns *Gas Station* 2013 oil on canvas 16 x 24"

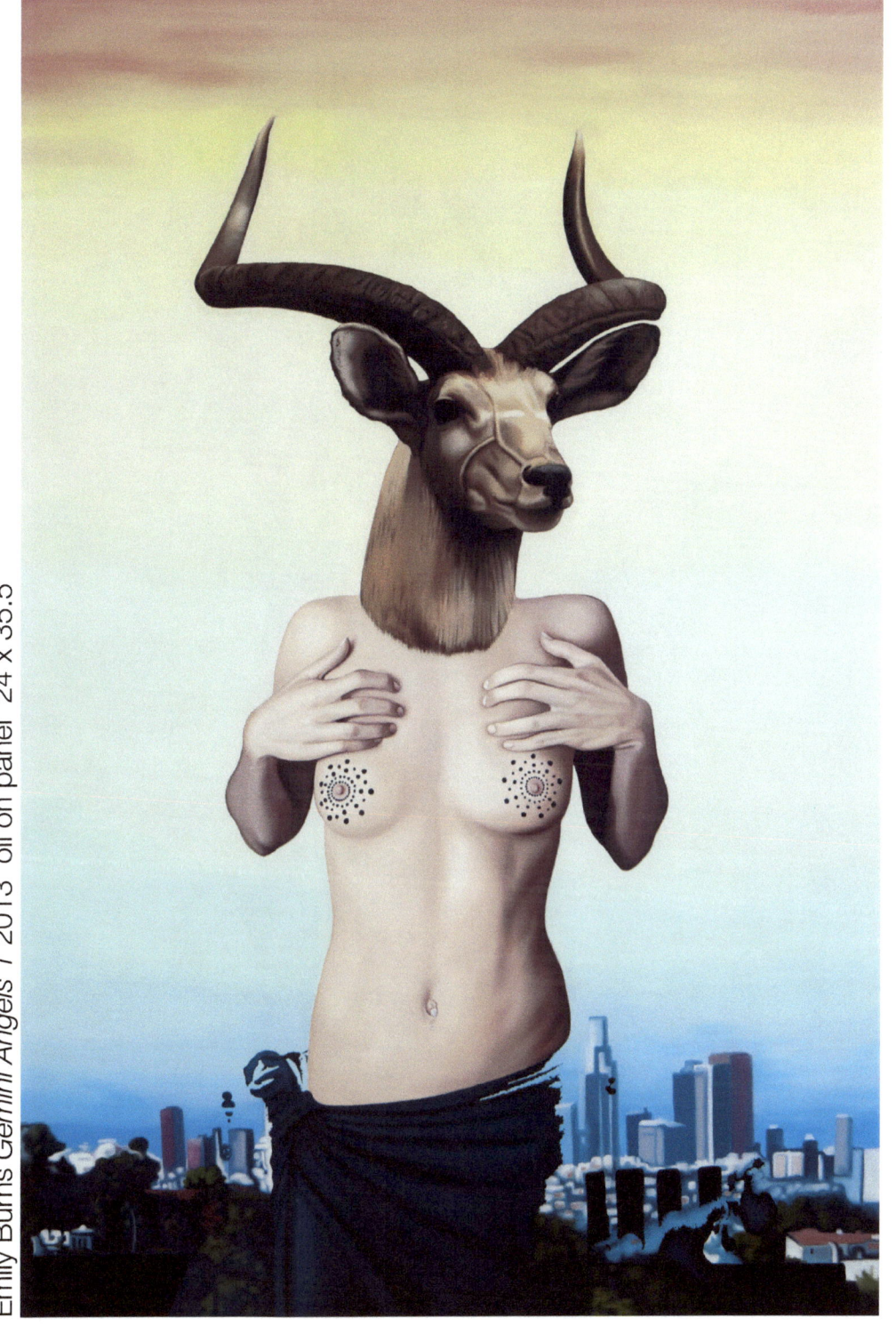

Emily Burns *Gemini Angels 2* 2013 oil on panel 24 x 35.5"

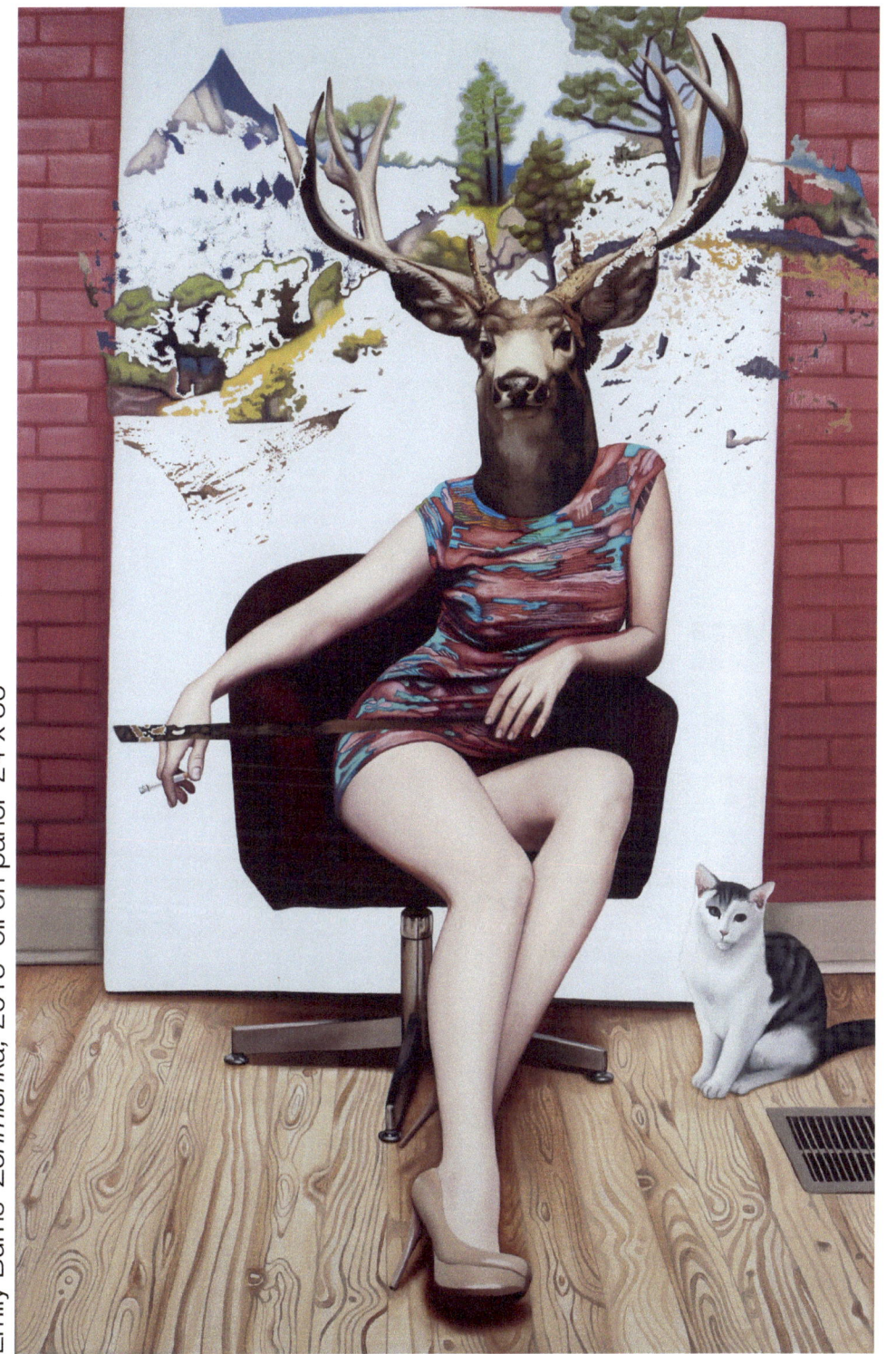

Emily Burns *Zenmishka*, 2013 oil on panel 24 x 36"

All 4 Volumes Now Available for the Kindle!

The Perspiration Principles

You Get What You Work For, Not What You Wish For.

Howard A. Tullman serves as Chairman of Tribeca Flashpoint Media Arts Academy. He is the former President of Kendall College in Chicago and the former Chairman/CEO of Experiencia, Inc. Mr. Tullman is the General Managing Partner for the Chicago High Tech Investors, LLC and for G2T3V, LLC. He is also the Chairman of the Endowment Committee of Anshe Emet Synagogue, a member of Mayor Emanuel's ChicagoNEXT and newly-formed Cultural Council, a member of Governor Quinn's Illinois Innovation Council and Illinois Arts Council, a member of President Preckwinkle's New Media Council, an Advisory Board member of HighTower Associates, Immerman Angels and uBID.COM and an Adjunct Professor at Northwestern's Kellogg School as well as a regular guest lecturer at the Northwestern University School of Law. Mr. Tullman also serves as a Director of Snapsheet, VEHCON and PackBack Books and served as a long-time Director and Board Chairman of The Cobalt Group, a Trustee of the Museum of Contemporary Art in Chicago and of the New York Academy of Art and the Mary and Leigh Block Museum of Art at Northwestern University, and as the lead Director (and briefly Chairman) of *The Princeton Review*.

Find out more at www.tullman.com.

www.ingramcontent.com/pod-product-compliance
Lightning Source LLC
Chambersburg PA
CBHW040753200526
45159CB00025B/1881